WATER'S EDGE

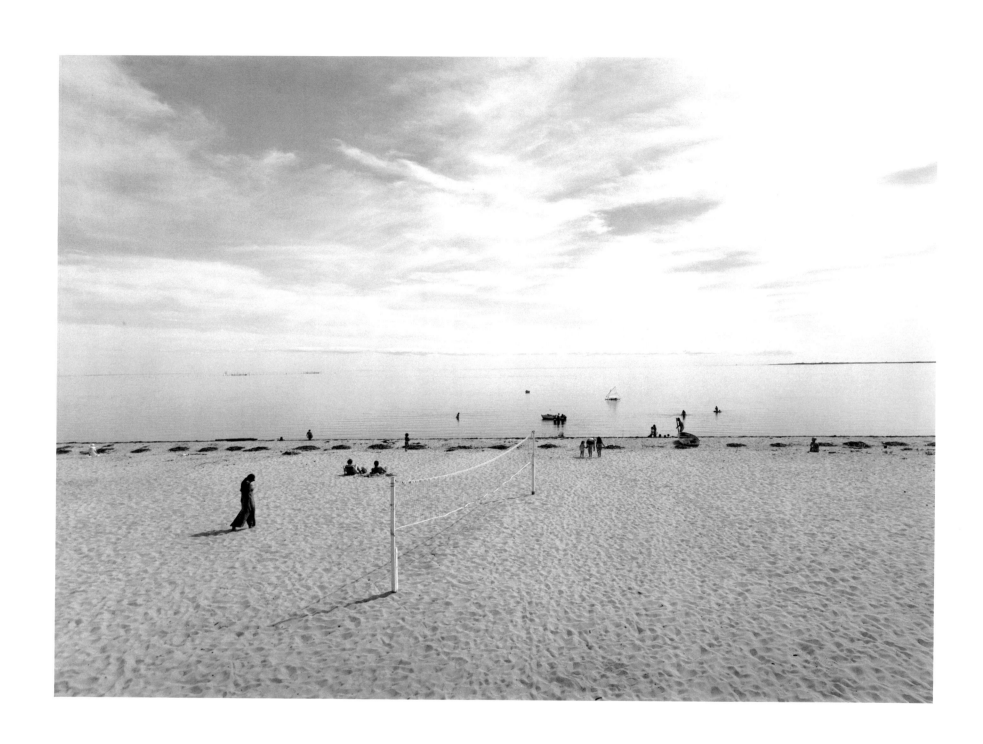

WATER'S EDGE

HARRY CALLAHAN

With an introductory poem by A. R. Ammons and an afterword by Harry Callahan

CALLAWAY EDITIONS

Distributed by The Viking Press

Published by Callaway Editions, Inc., Stewarts Corner, Lyme, Connecticut 06371

Distributed by The Viking Press, 625 Madison Avenue, New York, New York 10022

The afterword was edited from conversations between Mr. Callahan and the publisher
recorded in Providence, Rhode Island in May 1980.

The publisher would like to thank Charles Traub and the staff of LIGHT Gallery
for their help and cooperation in the preparation of this book.

Library of Congress Card Catalog number: 80-66639
ISBN: Trade Edition 0-935112-01-4 Deluxe Edition 0-935112-02-2

Frontispiece: 1 CAPE COD 1972

WATER'S EDGE

CORSONS INLET

I went for a walk over the dunes again this morning
to the sea,
then turned right along
 the surf
 rounded a naked headland
 and returned

 along the inlet shore:

it was muggy sunny, the wind from the sea steady and high,
crisp in the running sand,
 some breakthroughs of sun
 but after a bit

continuous overcast:

the walk liberating, I was released from forms,
from the perpendiculars,
 straight lines, blocks, boxes, binds
of thought
into the hues, shadings, rises, flowing bends and blends
 of sight:

 I allow myself eddies of meaning:
yield to a direction of significance
running
like a stream through the geography of my work:
 you can find
in my sayings
 swerves of action
 like the inlet's cutting edge:
 there are dunes of motion,
organizations of grass, white sandy paths of remembrance
in the overall wandering of mirroring mind:

but Overall is beyond me: is the sum of these events
I cannot draw, the ledger I cannot keep, the accounting
beyond the account:

in nature there are few sharp lines: there are areas of
primrose
 more or less dispersed;
disorderly orders of bayberry; between the rows
of dunes,
irregular swamps of reeds,
though not reeds alone, but grass, bayberry, yarrow, all . . .
predominantly reeds:

I have reached no conclusions, have erected no boundaries,
shutting out and shutting in, separating inside
 from outside: I have
 drawn no lines:
 as

manifold events of sand
change the dune's shape that will not be the same shape
tomorrow,

so I am willing to go along, to accept
the becoming
thought, to stake off no beginnings or ends, establish
 no walls:

by transitions the land falls from grassy dunes to creek
to undercreek: but there are no lines, though
 change in that transition is clear
 as any sharpness: but "sharpness" spread out,
allowed to occur over a wider range
than mental lines can keep:

the moon was full last night: today, low tide was low:
black shoals of mussels exposed to the risk
of air

and, earlier, of sun,
waved in and out with the waterline, waterline inexact,
caught always in the event of change:
 a young mottled gull stood free on the shoals
 and ate
to vomiting: another gull, squawking possession, cracked a crab,
picked out the entrails, swallowed the soft-shelled legs, a ruddy
turnstone running in to snatch leftover bits:

risk is full: every living thing in
siege: the demand is life, to keep life: the small
white blacklegged egret, how beautiful, quietly stalks and spears
 the shallows, darts to shore
 to stab—what? I couldn't
 see against the black mudflats—a frightened
 fiddler crab?

 the news to my left over the dunes and
reeds and bayberry clumps was
 fall: thousands of tree swallows
 gathering for flight:
 an order held
 in constant change: a congregation
rich with entropy: nevertheless, separable, noticeable
 as one event,
 not chaos: preparations for
flight from winter,
cheet, cheet, cheet, cheet, wings rifling the green clumps,
beaks
at the bayberries
 a perception full of wind, flight, curve,
 sound:
 the possibility of rule as the sum of rulelessness:
the "field" of action
with moving, incalculable center:

in the smaller view, order tight with shape:
blue tiny flowers on a leafless weed: carapace of crab:

snail shell:

 pulsations of order

 in the bellies of minnows: orders swallowed,
broken down, transferred through membranes
to strengthen larger orders: but in the large view, no
lines or changeless shapes: the working in and out, together
 and against, of millions of events: this,
 so that I make
 no form of
 formlessness:

orders as summaries, as outcomes of actions override
or in some way result, not predictably (seeing me gain
the top of a dune,
the swallows
could take flight—some other fields of bayberry
 could enter fall
 berryless) and there is serenity:

 no arranged terror: no forcing of image, plan,
or thought:
no propaganda, no humbling of reality to precept:

terror pervades but is not arranged, all possibilities
of escape open: no route shut, except in
 the sudden loss of all routes:

 I see narrow orders, limited tightness, but will
not run to that easy victory:
 still around the looser, wider forces work:
 I will try
 to fasten into order enlarging grasps of disorder, widening
scope, but enjoying the freedom that
Scope eludes my grasp, that there is no finality of vision,
that I have perceived nothing completely,
 that tomorrow a new walk is a new walk.

A. R. AMMONS

PLATES

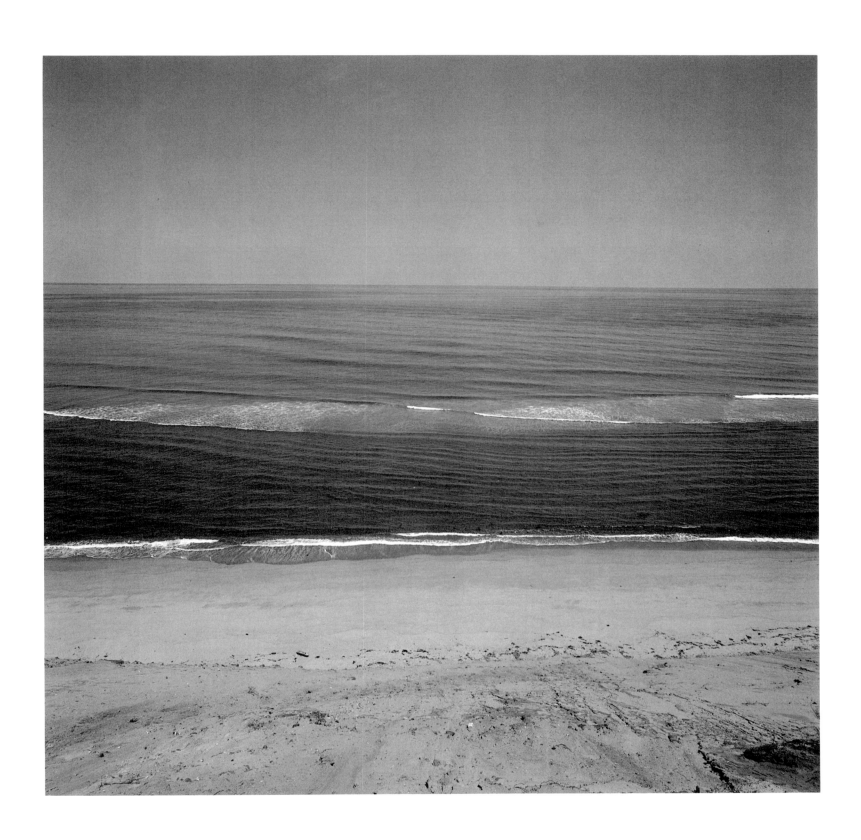

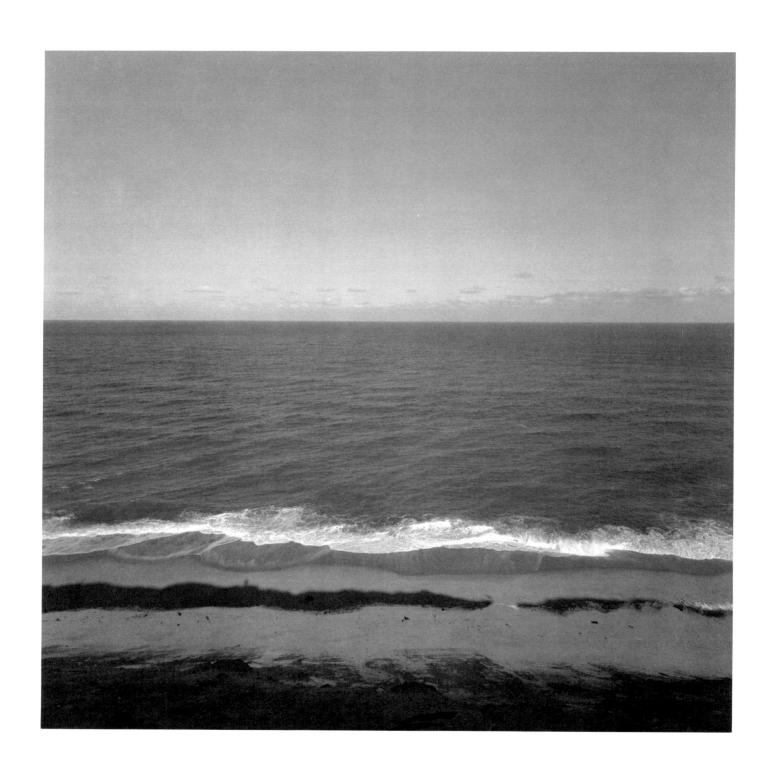

3 CAPE COD 1974

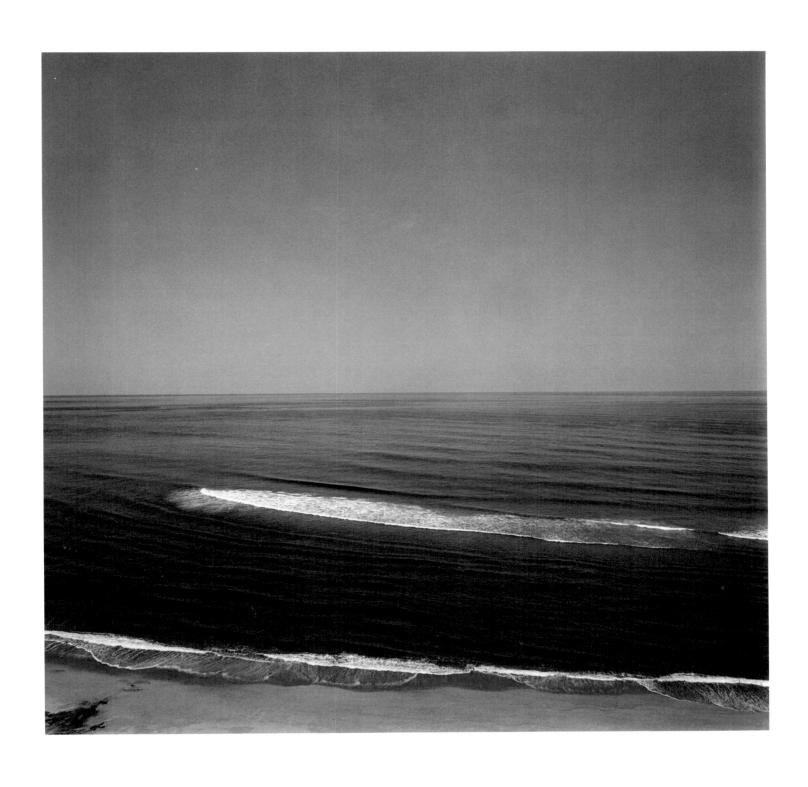

4 CAPE COD 1973

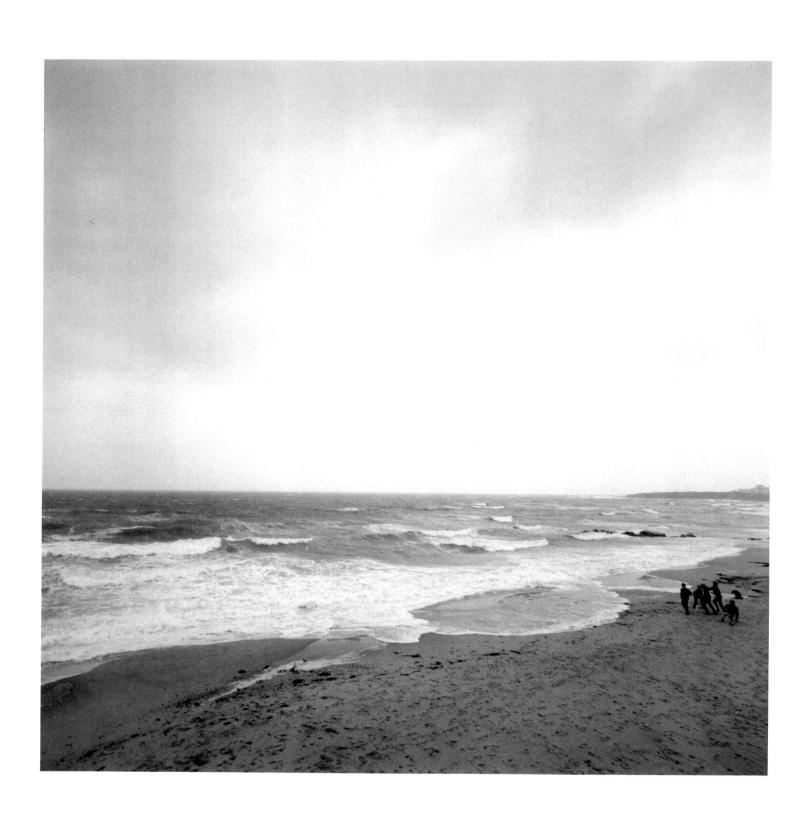

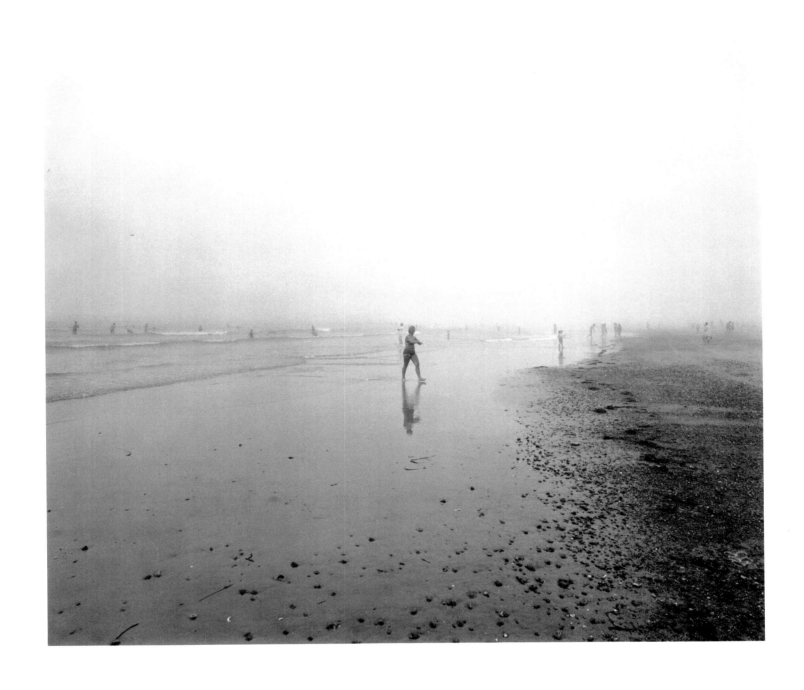

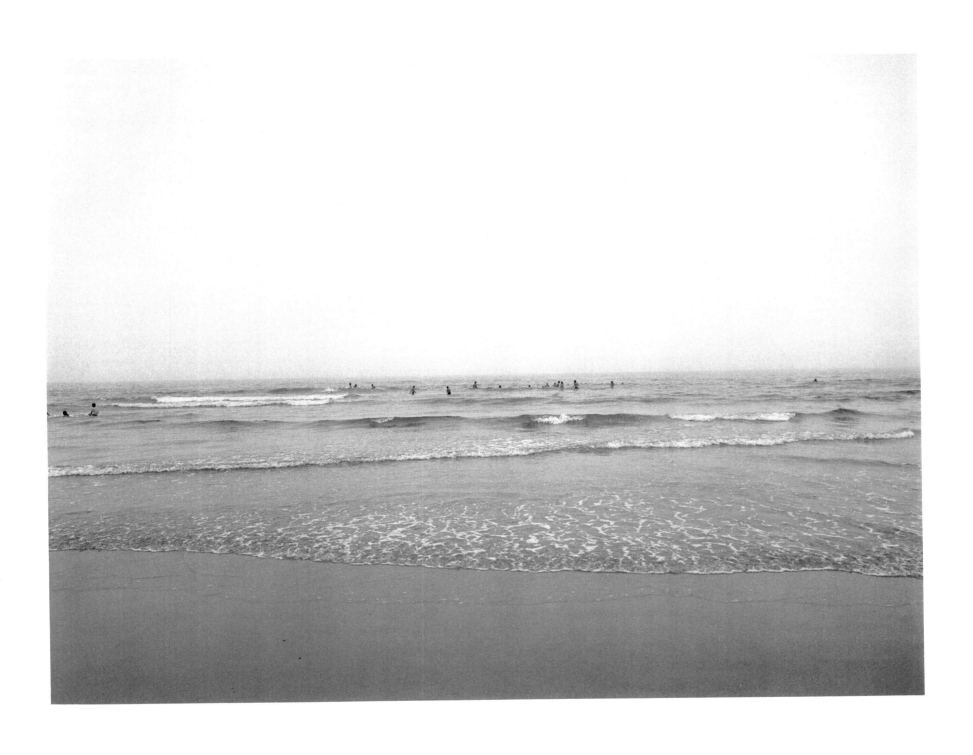

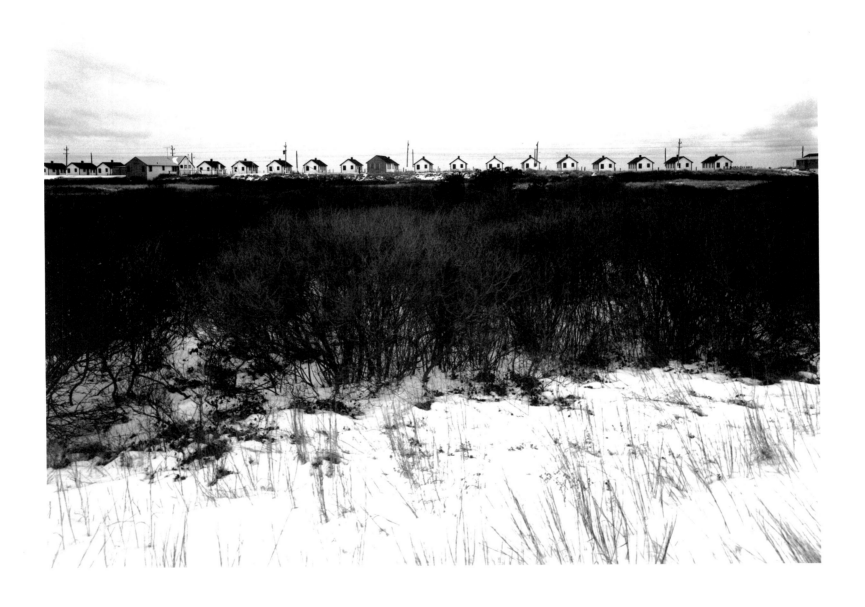

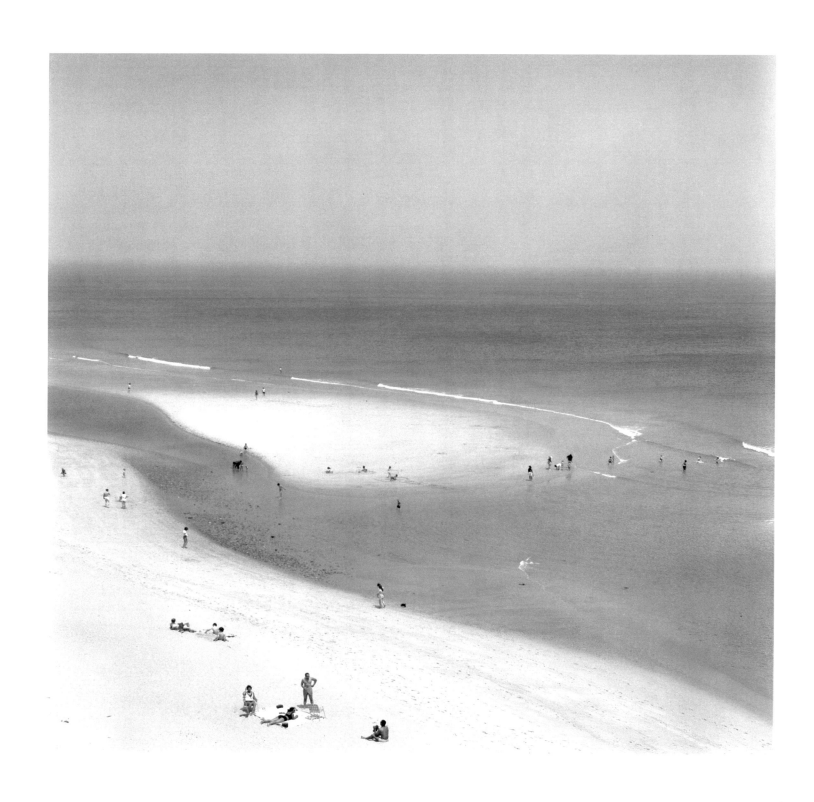

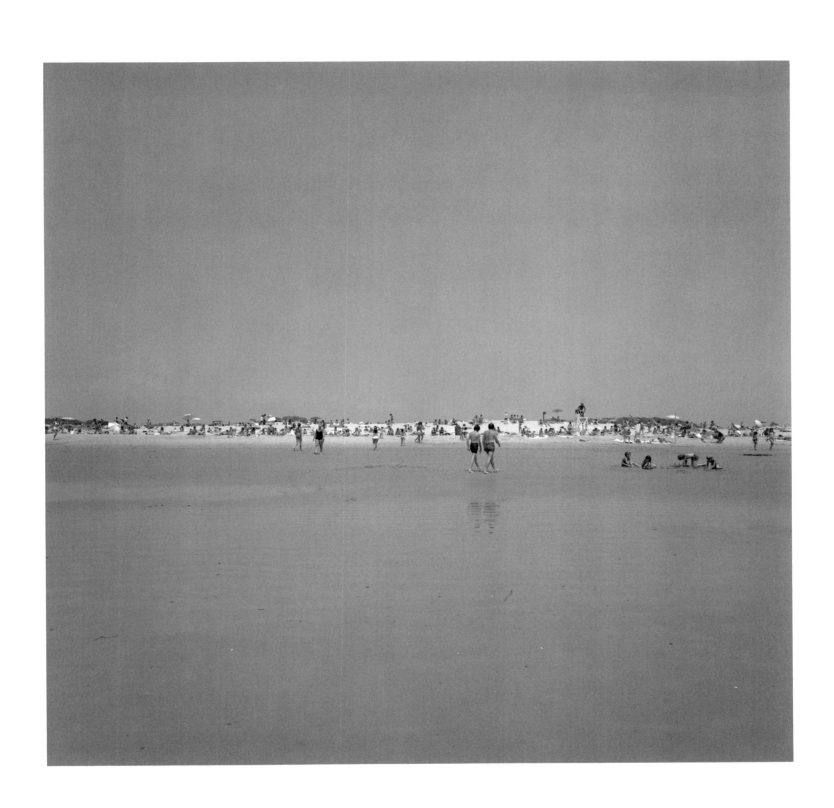

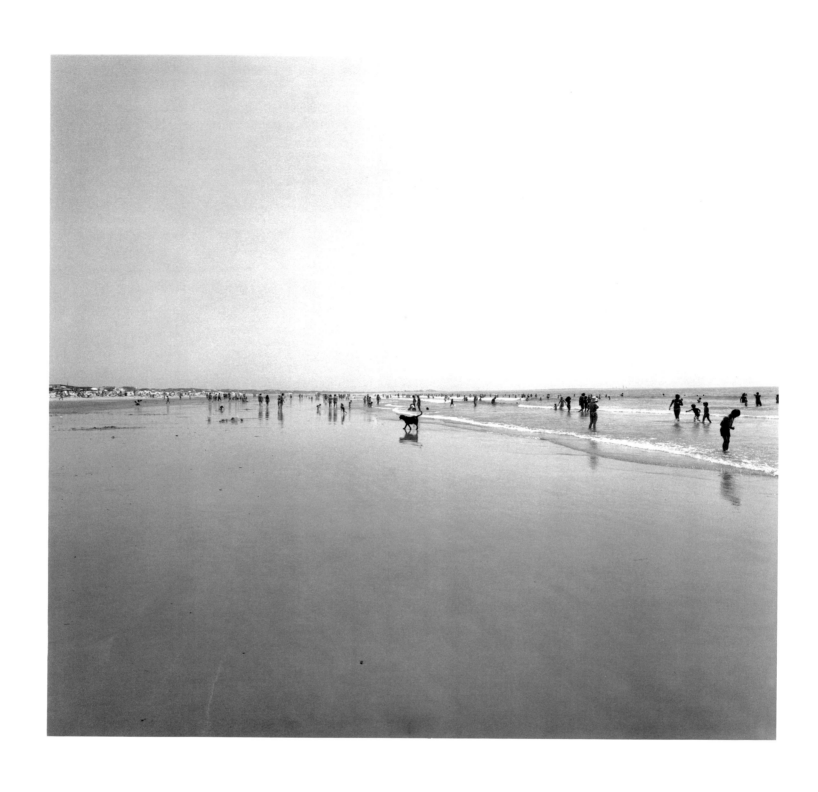

11 HORSENECK BEACH 1974

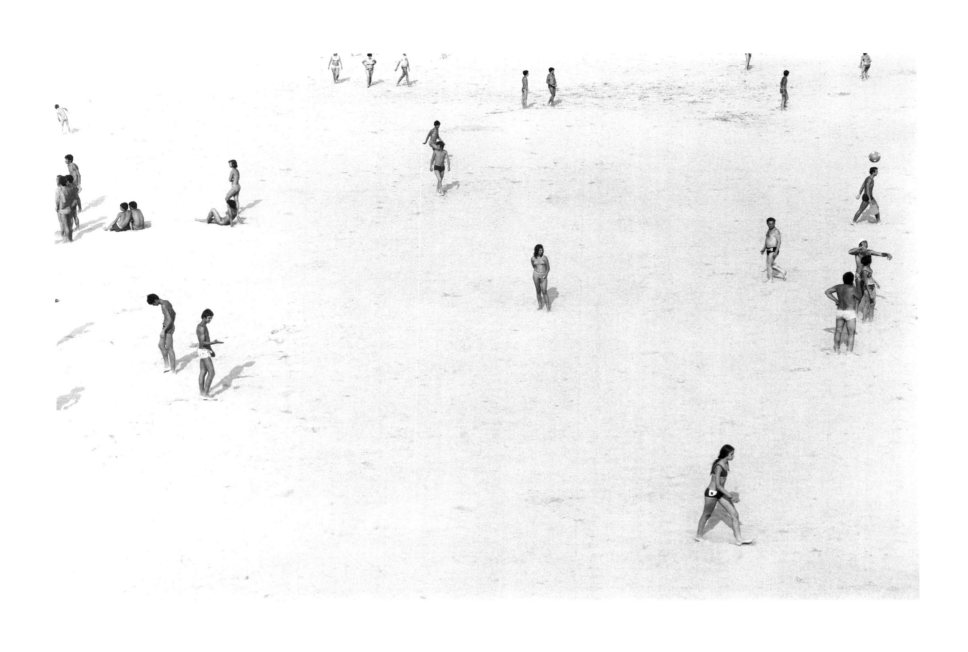

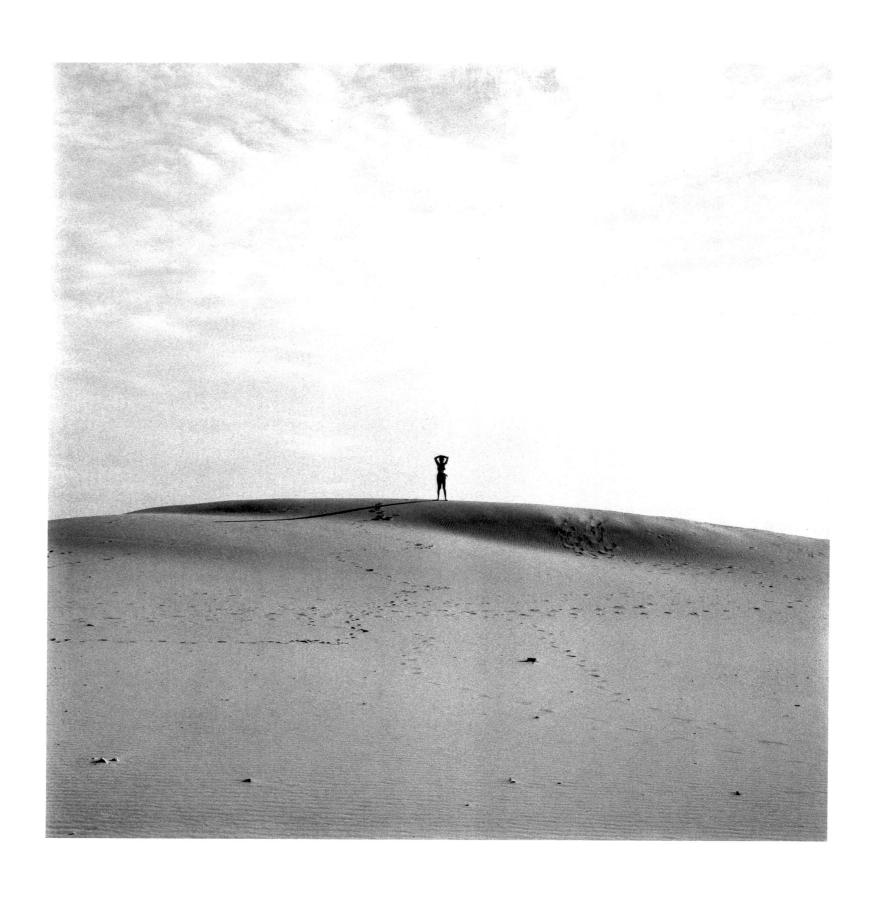

13 ELEANOR, INDIANA 1948

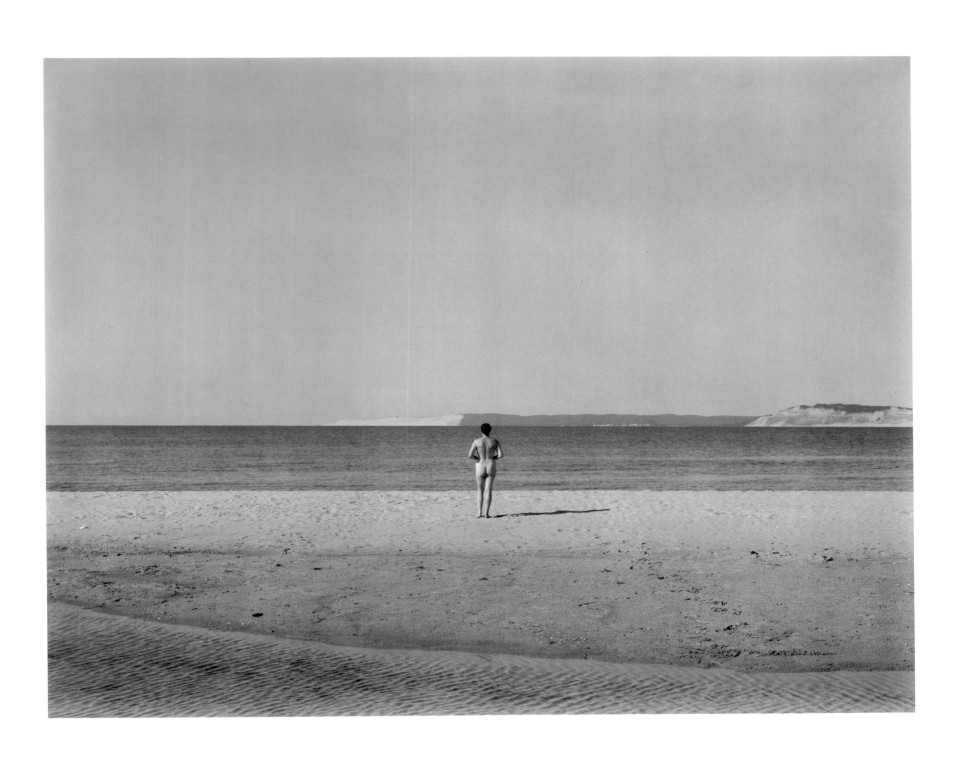

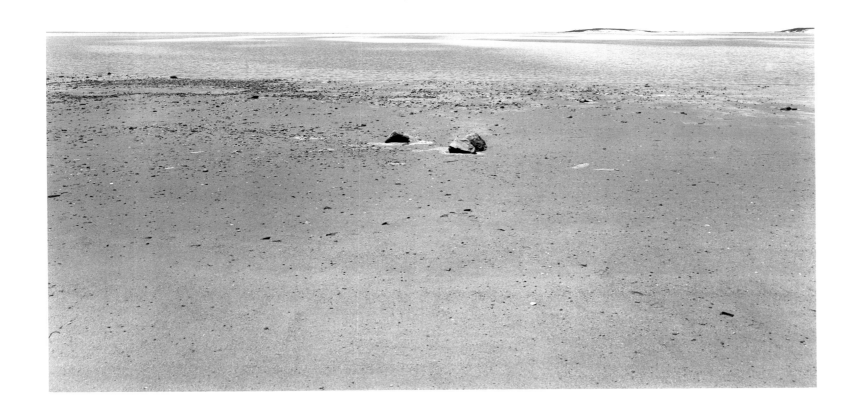

15 CAPE COD 1972

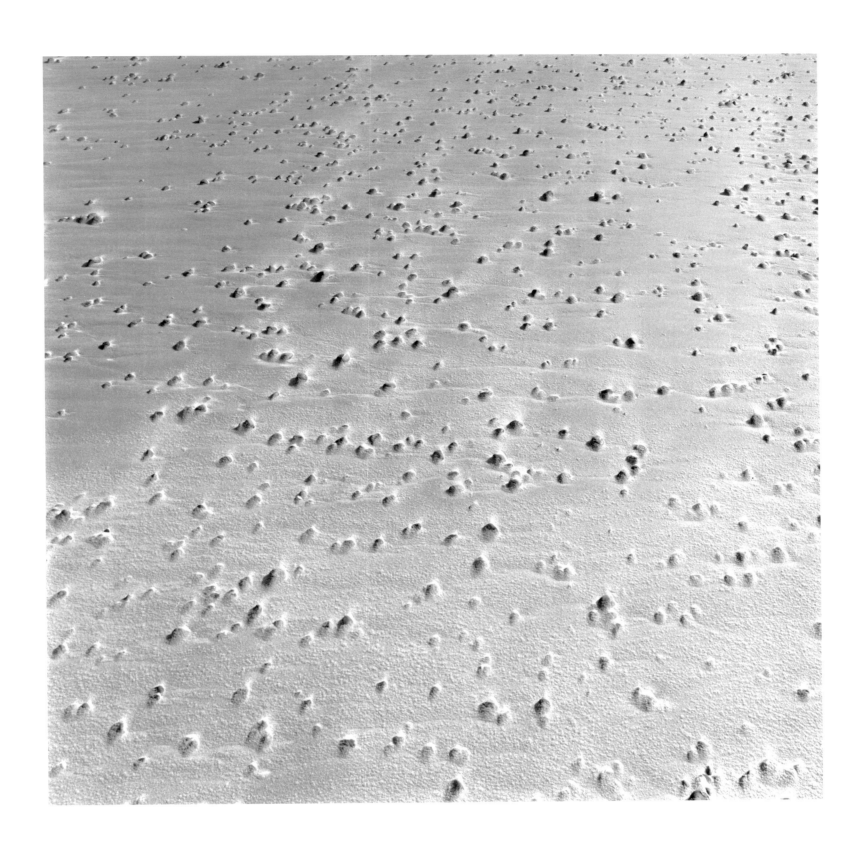

16 CAPE COD 1973

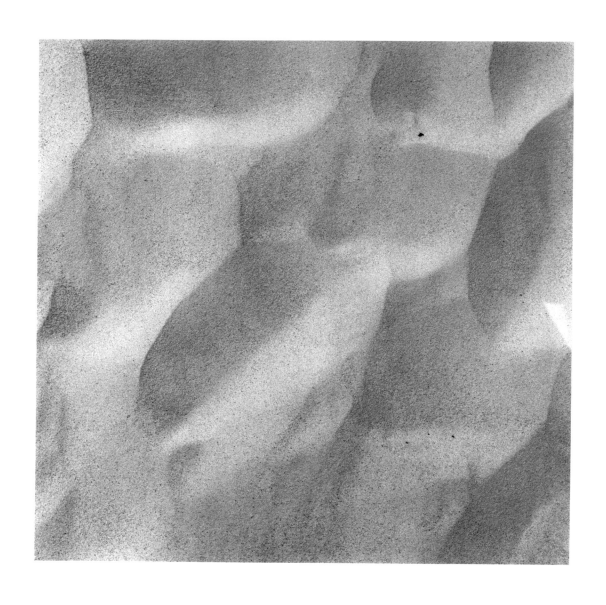

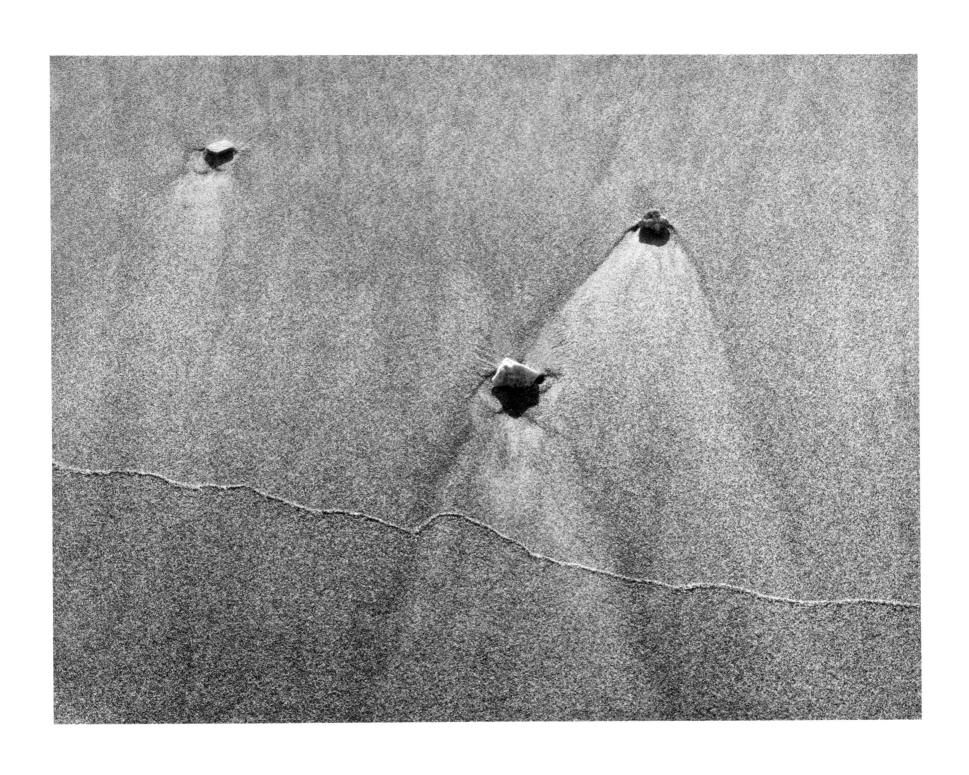

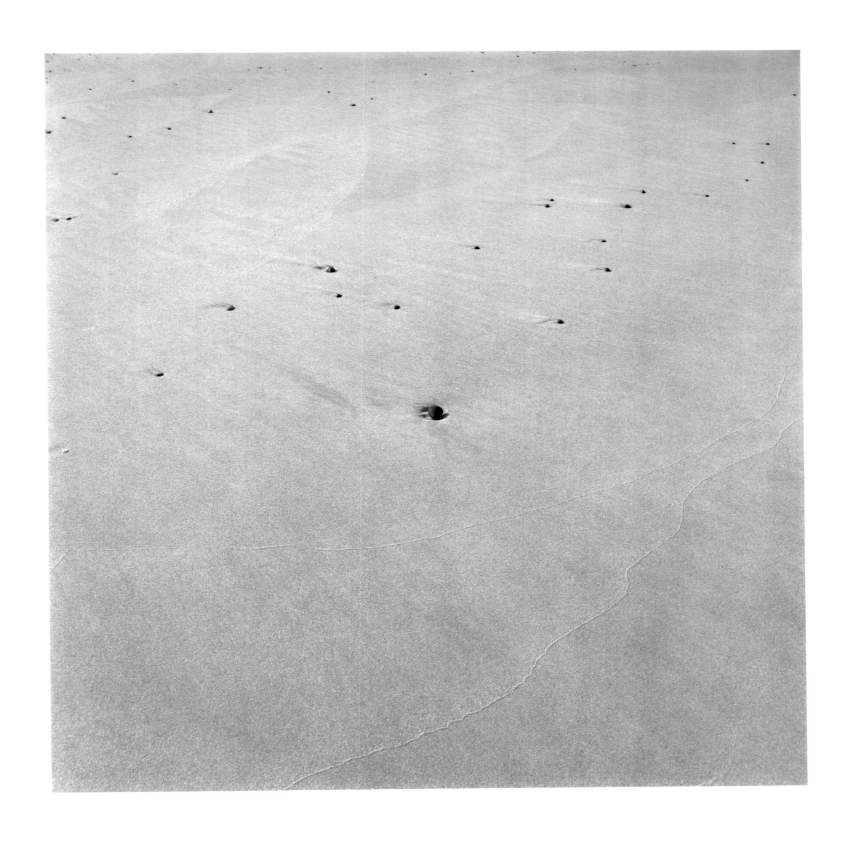

19 CAPE COD 1973

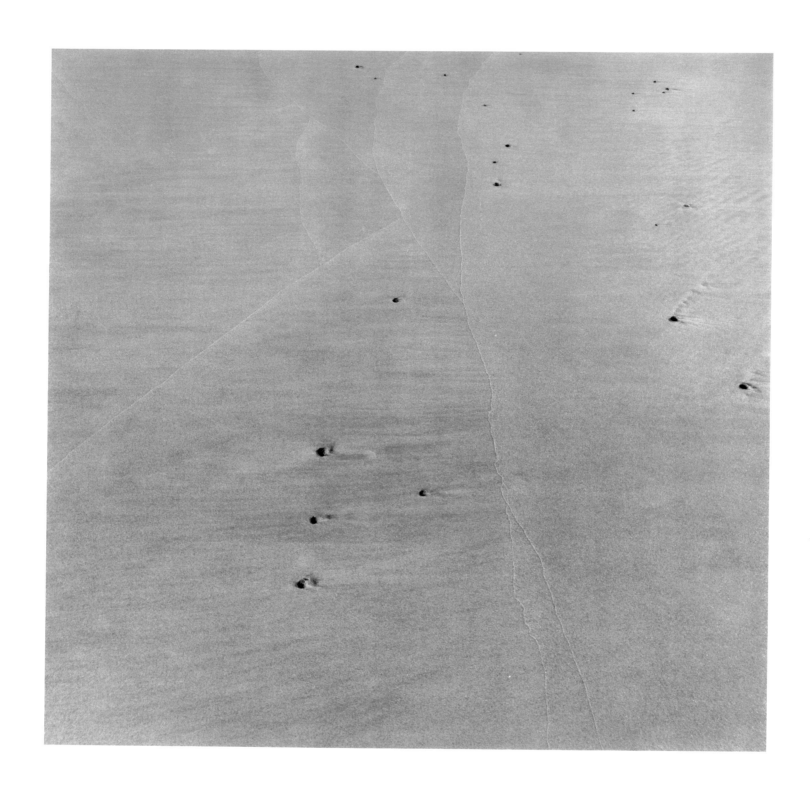

20 CAPE COD 1973

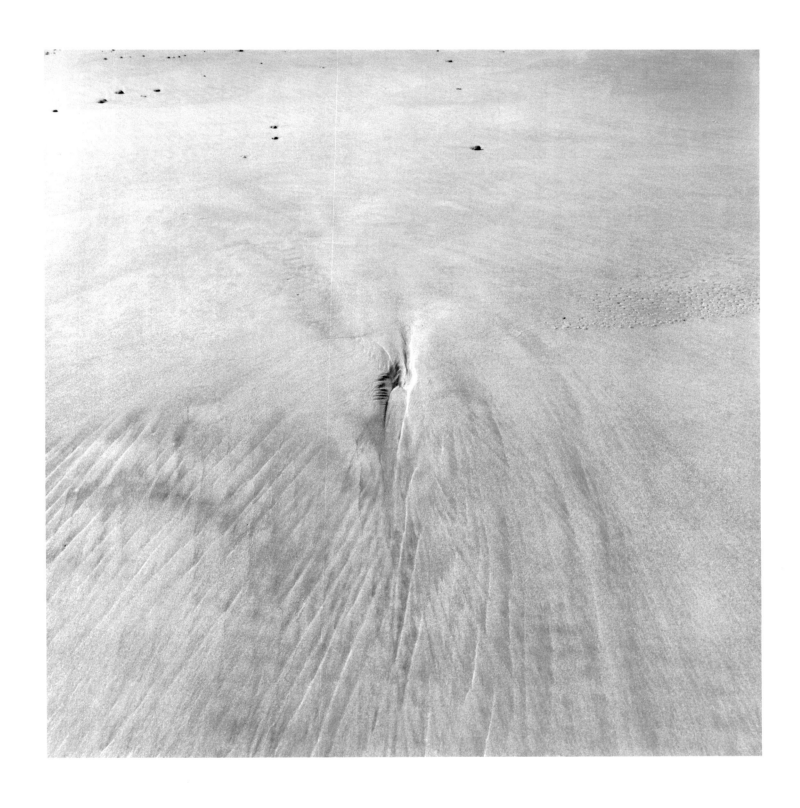

21 CAPE COD 1973

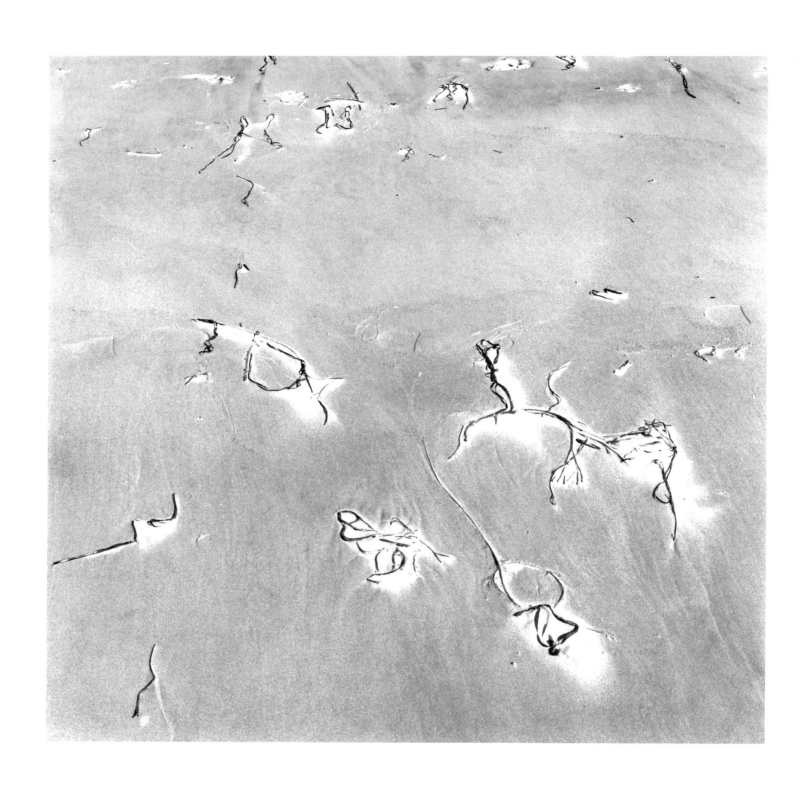

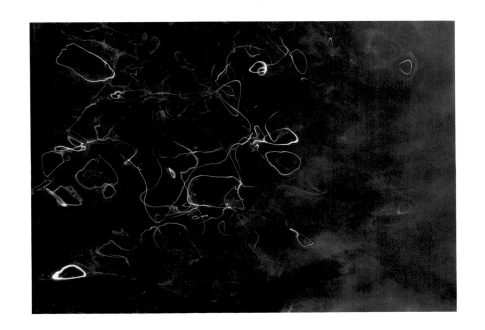

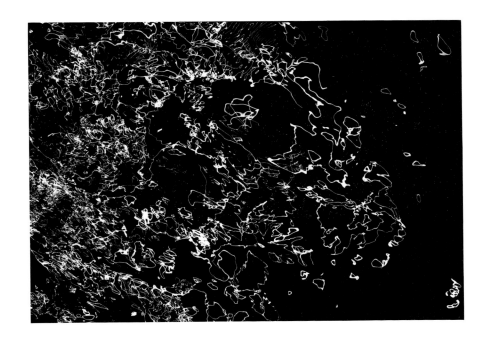

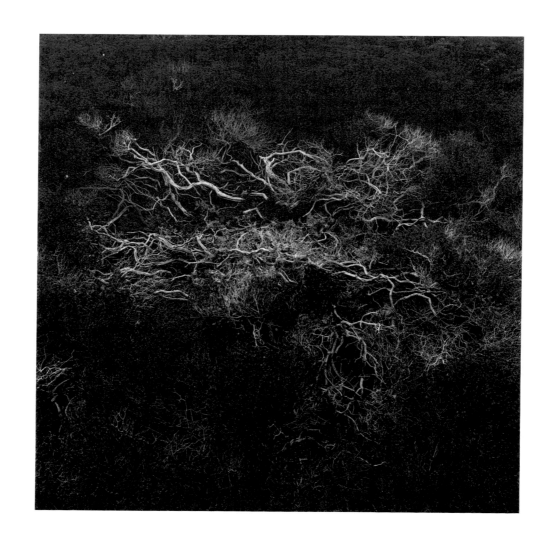

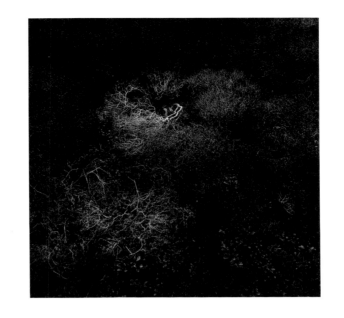

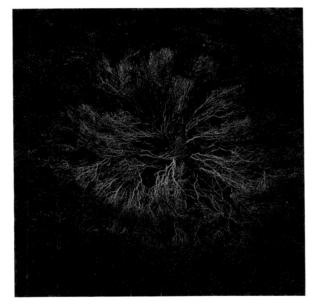

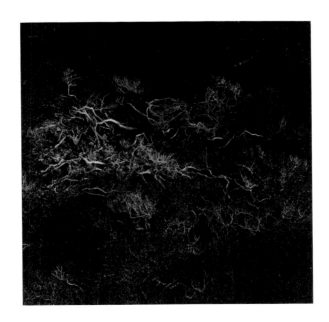

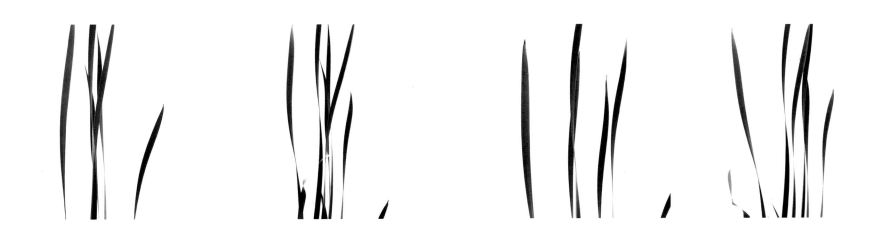

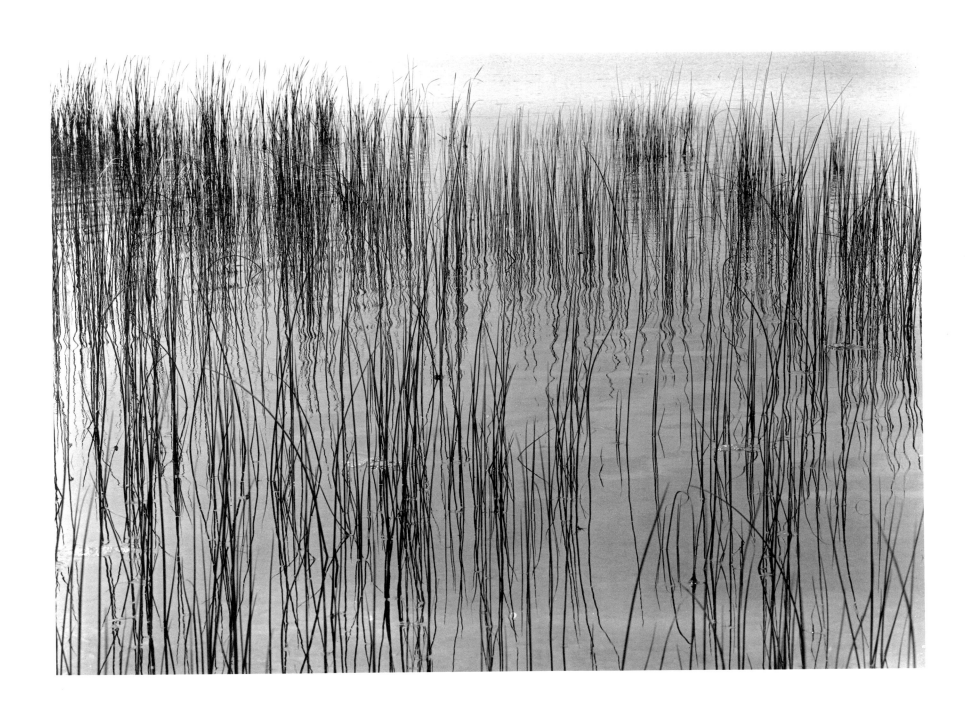

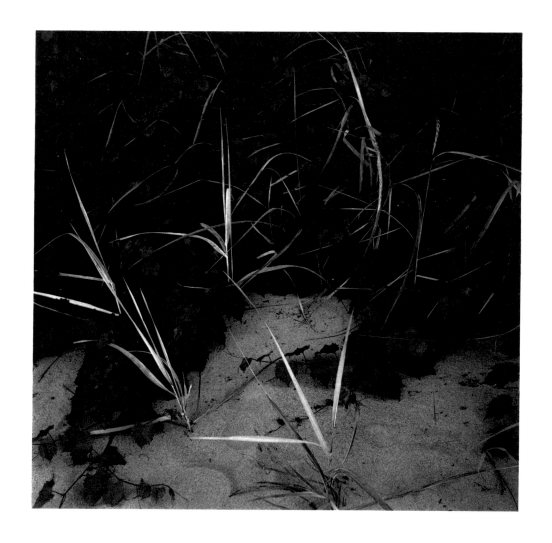

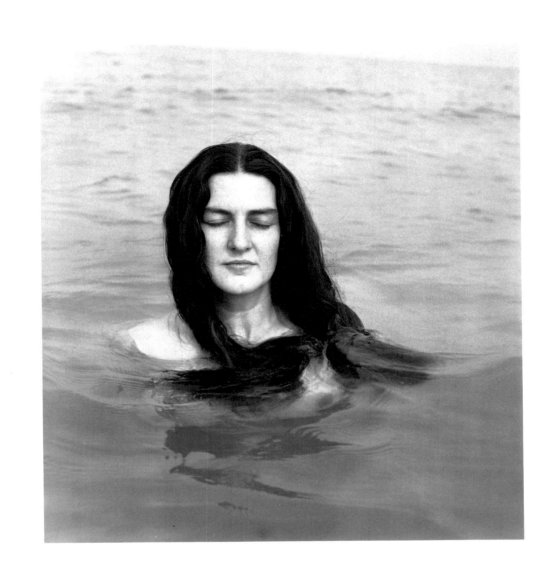

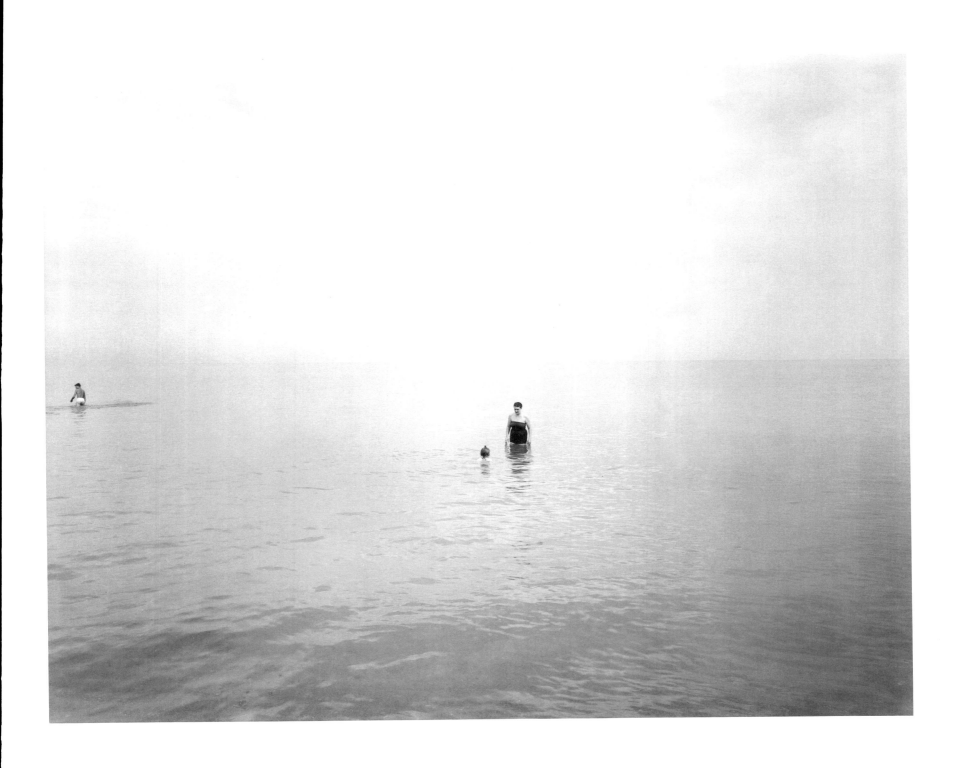

33 LAKE MICHIGAN 1953

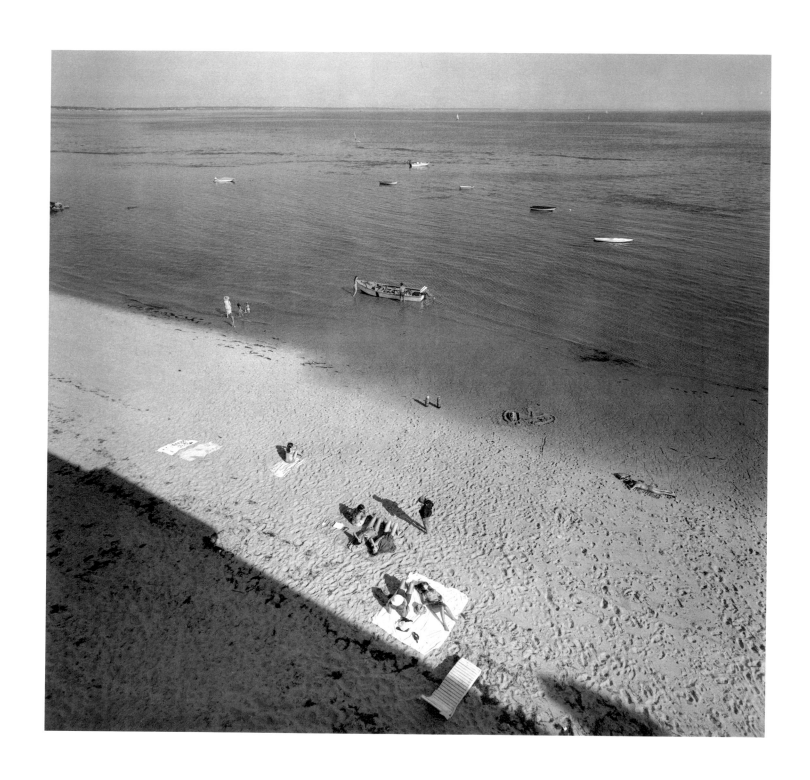

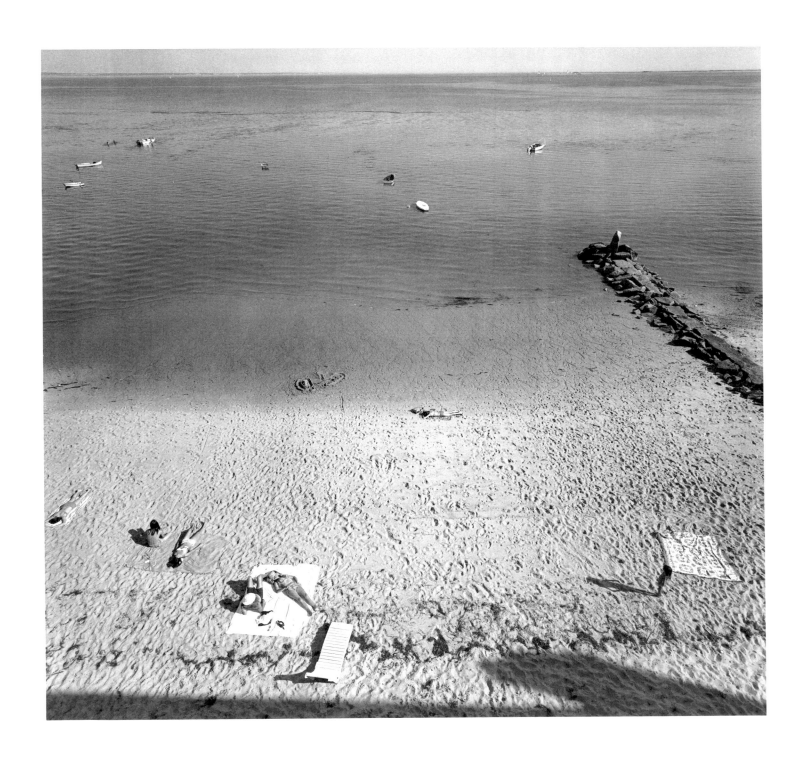

34 35 CAPE COD 1972

36 37 CAPE COD 1972

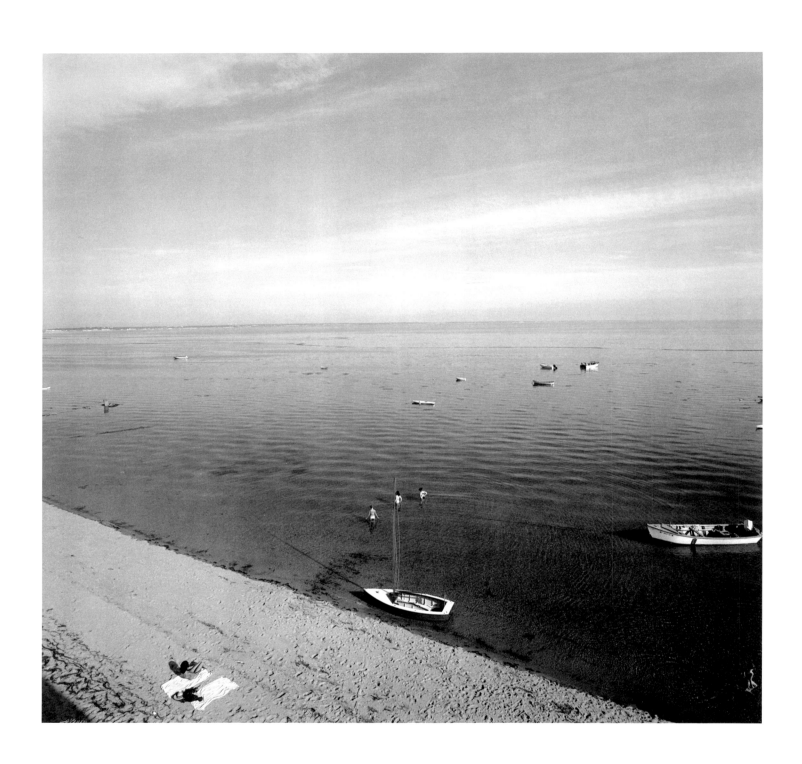

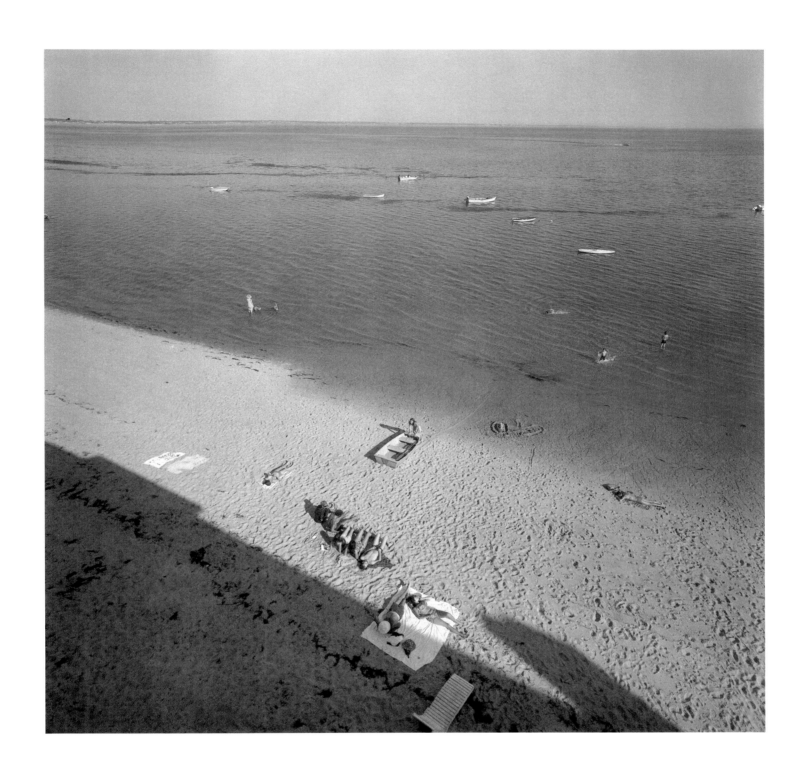

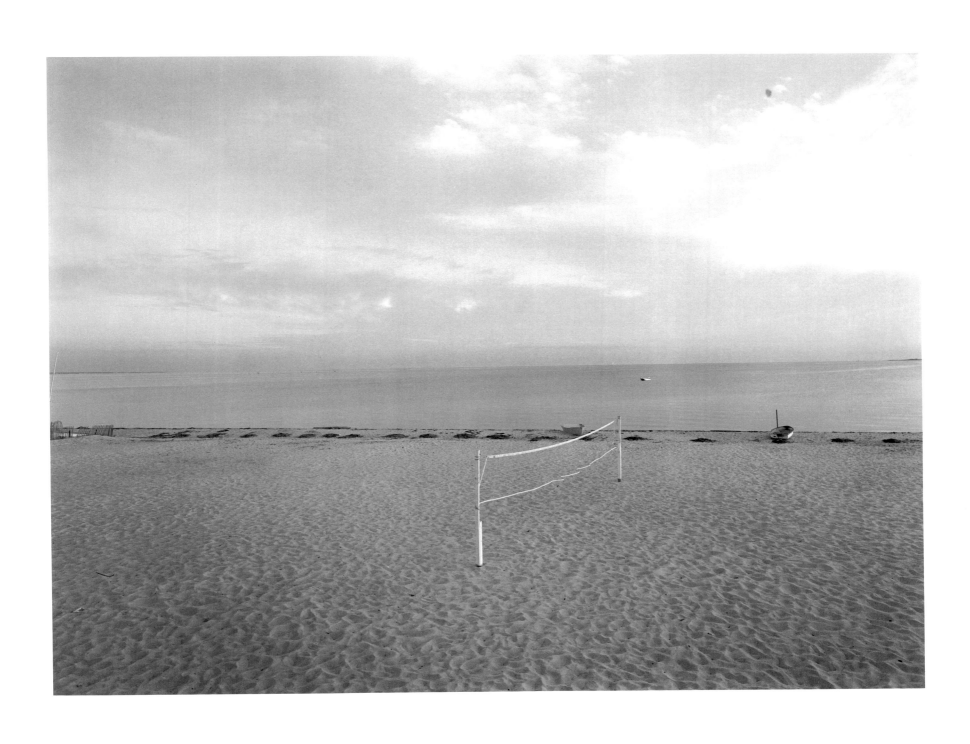

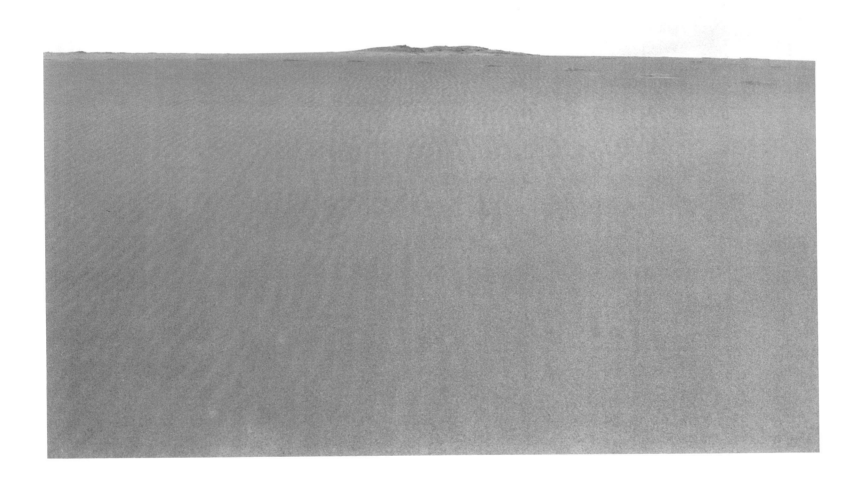

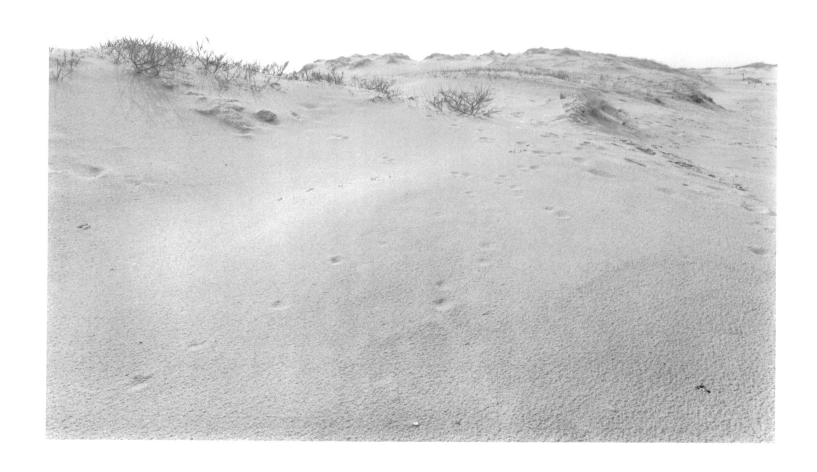

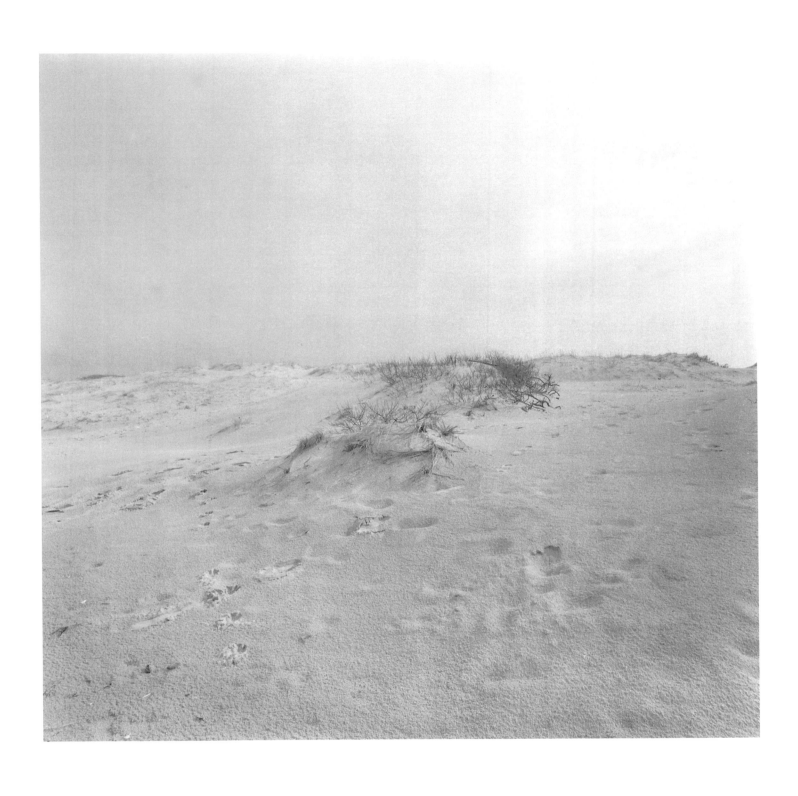

41 HORSENECK BEACH 1971

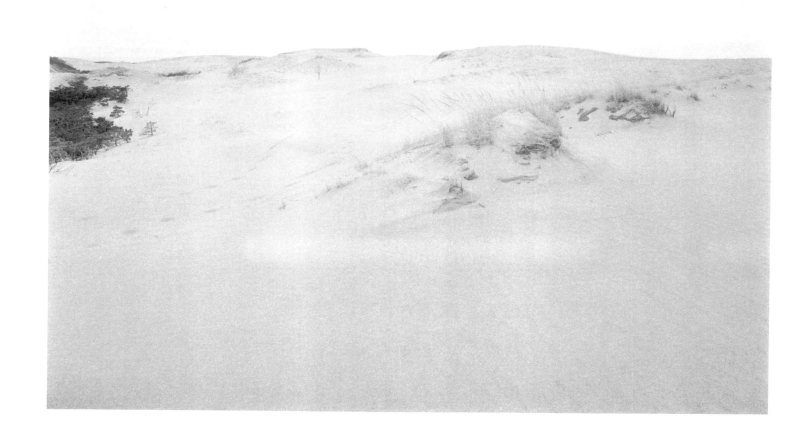

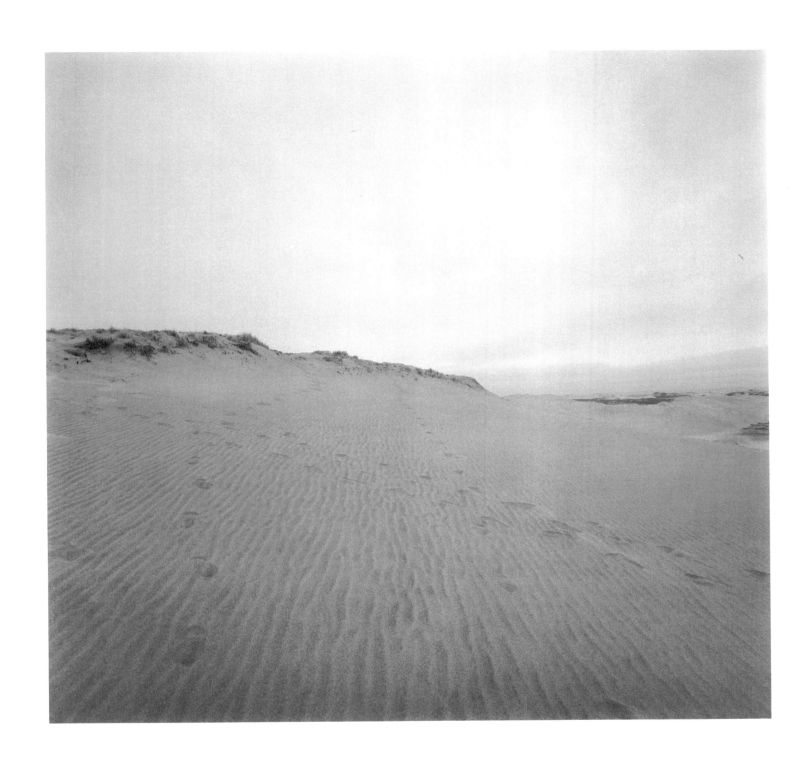

43 CAPE COD 1971

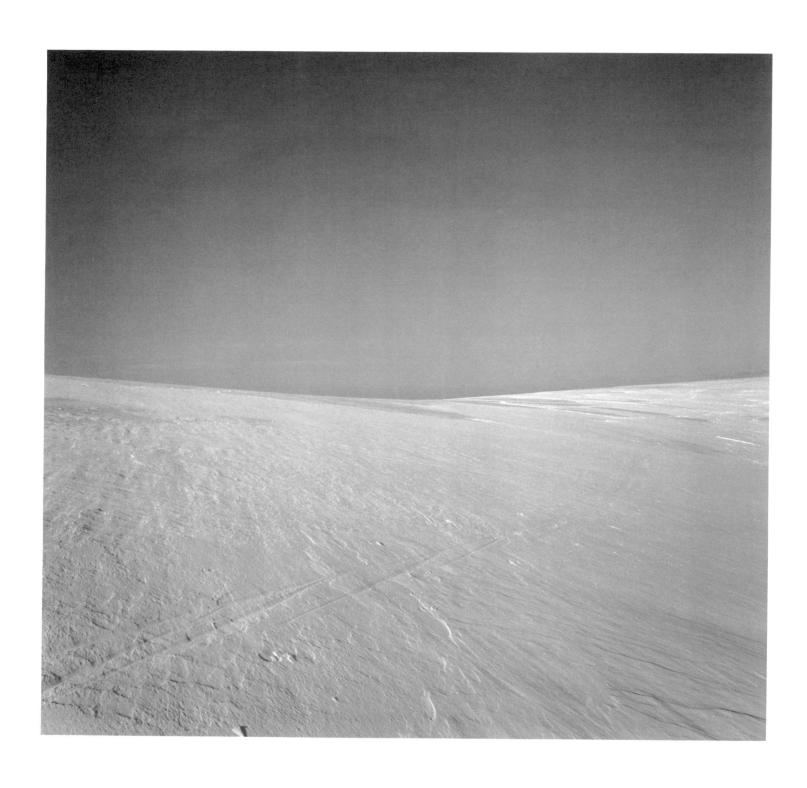

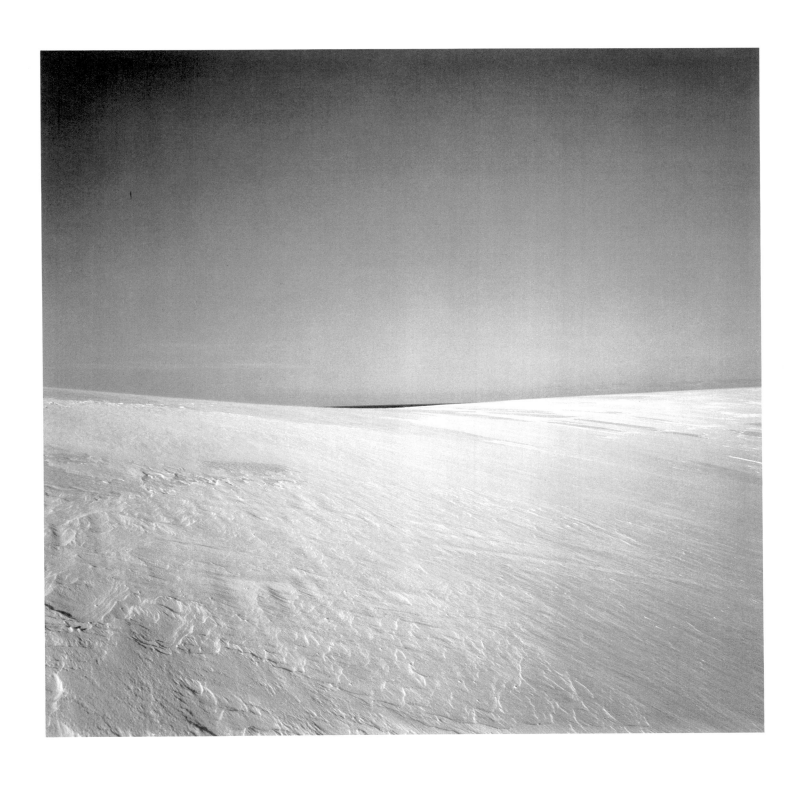

45 CAPE COD 1974

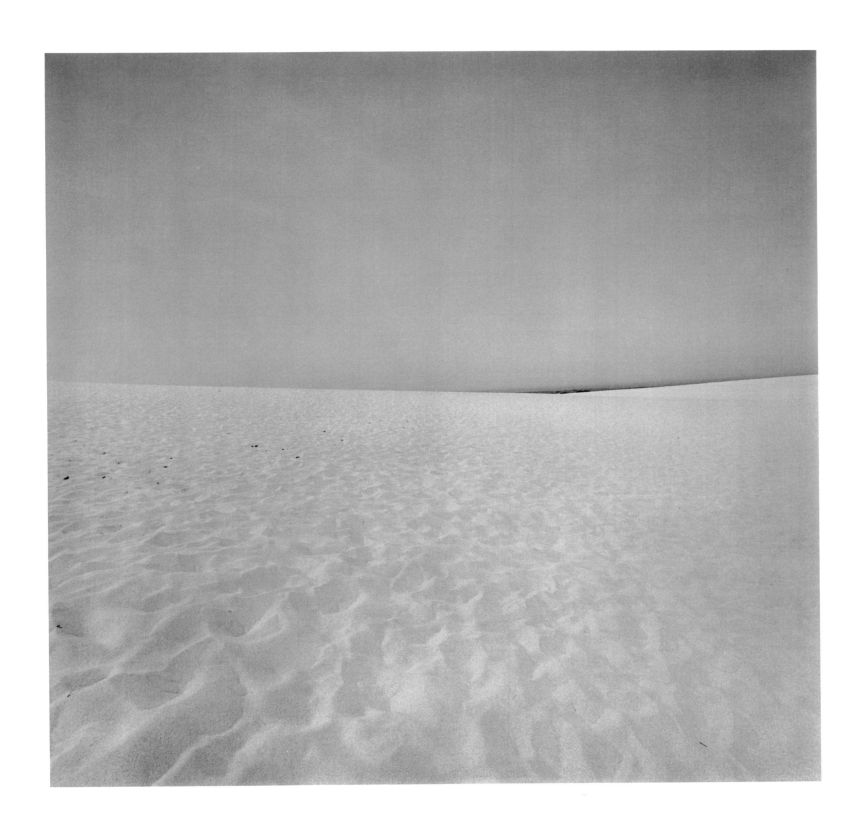

46 CAPE COD 1972

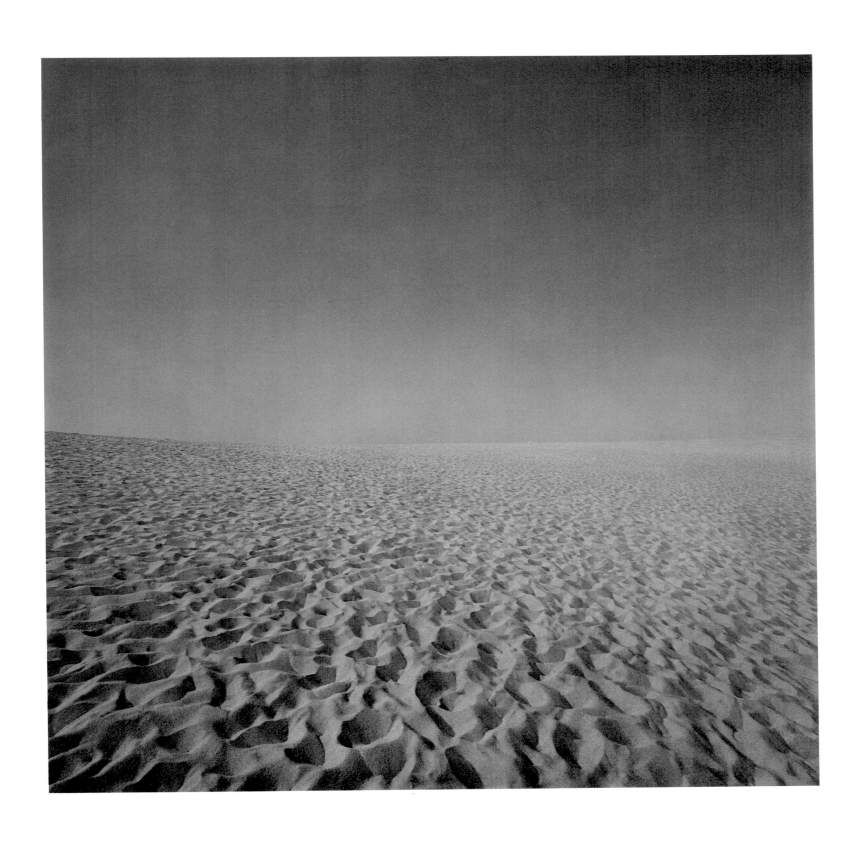

47 CAPE COD 1972

AFTERWORD

To write about the Beach Series, I feel I must also write about my life and my photography.

In 1941 Ansel Adams came to Detroit to exhibit and speak. I hadn't seen really serious photographs that I related to before then. His photographs and attitude freed me and made me realize that I didn't have to photograph the "Grand Landscape" to make a good picture—that had already been done. I knew that I didn't have to get in the car and drive to the mountains to photograph what I wanted. I could make a picture within ten feet of myself—it was all right there.

I've always loved to walk and a long, long beach is a wonderful place for that—to go out and walk and unwind and then start photographing. The series had its start around 1938 at Lake Huron, where Eleanor's family had a cottage. But it was later, in 1946 in Chicago, that I made what I consider to be my first good sand pictures. We lived three or four blocks from Lake Michigan, and my love of walking and photographing led me to that beach. I would look up at the buildings along the shore, but then I would also look down to the marvellous lines of the sand made by the water—the beautiful colors of the sand, rocks and pebbles, and the water shapes moving in. Those winters in Chicago were particularly powerful for me. I would go down to the lakefront in the cold and always find a few lonesome people wandering around on the shore. I like to think that they were feeling the same fascination with the place that I was. When we moved to New England in 1961 I was soon at the ocean and I remember how good I felt to be at a powerful water's edge; I thought back to those days at Lake Huron and Lake Michigan.

My love for photography has been such that I want to photograph as much as possible. The water's edge is a theme that has meant a great deal and has stayed with me over the last

forty years. I think that the best of these beach pictures represents a finding of my kind of vision. It has changed and grown over the years, and different subjects continue to mean different kinds of things. I know that the seeds were sown forty years ago, but I also know that I wasn't fully conscious of where I was going then. What you are about doesn't come out all at once with your first successful picture. Only as time goes by do you finally arrive at something you were unconsciously after—which is a wonderful surprise. It is said that the poetic part of a person's life is when he is young, but the mature part of the artist is when he is old. I think I have begun to understand that now, and I know it relates to my own photography.

My concern is the art of telling you something about my instinctive visual life. Not through storytelling photographs, but through something that has developed from an enormous body of work. And it is not a certain kind of style that I am concerned with. For me that is not enough—that is like spending a lifetime gathering a butterfly collection.

I think that nearly every artist continually wants to reach the edge of nothingness—the point where you can't go any farther. I feel I have come close to that at various times with the Beach Series photographs. A determined single-mindedness and an insistent inner need has led me to that point. That is why I have always kept going back, and that is what still keeps me going today—keeps me alive.

HARRY CALLAHAN

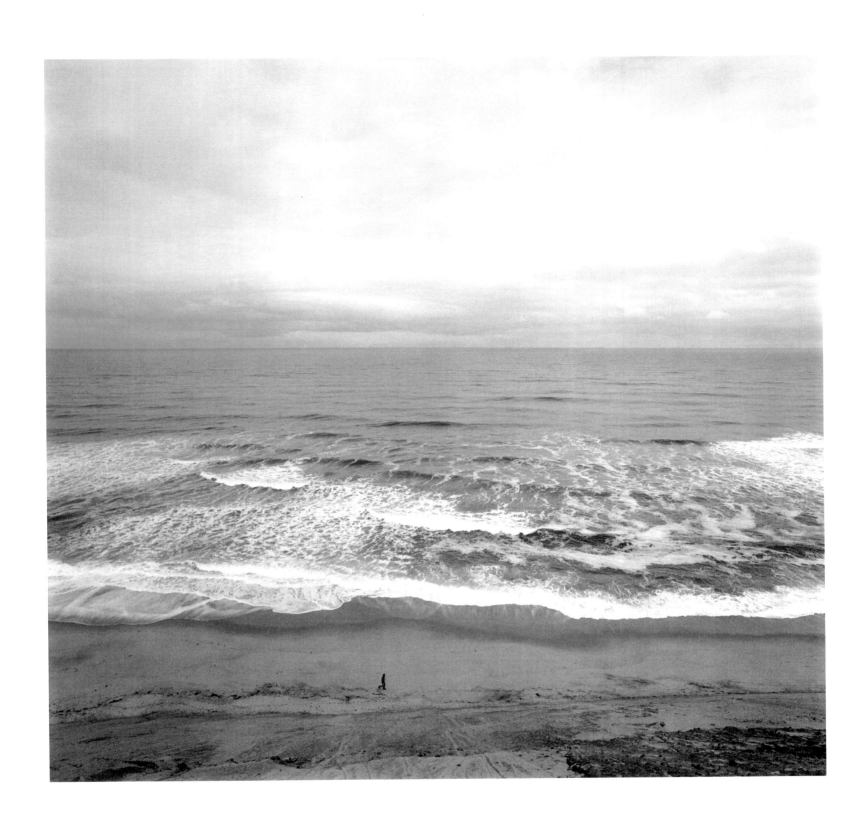

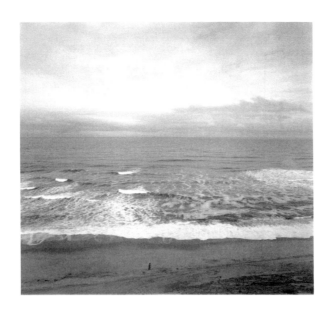

WATER'S EDGE has been published in this first edition of 5,000 copies. The duotone plates have been laser-scanned directly from the original photographs and printed in 300-line screen offset lithography by Acme Printing Company. The text, Aldus, was set by DEKR Corporation, and the titling, Michelangelo, by Thomas Todd Company; both were designed by Hermann Zapf. The paper, 100 lb. Quintessence text, has been supplied by Andrews/Nelson/Whitehead, and the binding is by Tapley-Rutter. The book was designed by Nicholas Callaway and Anne Kennedy, with Katy Homans.

WATER'S EDGE has also been published in a deluxe edition of 216 copies, signed by Harry Callahan and numbered 1 through 200 with 16 additional copies reserved for the artist and the publisher. The book has been specially bound in Dutch linen and enclosed in a quarter-vellum tray case handmade by Lisa Callaway. Each copy includes an original photograph printed especially for this edition by Harry Callahan. The photograph has been archivally produced and mounted on debossed, pure rag Fabriano Tiepolo Etching paper. For this edition, four images were selected from the book and a set of fifty prints was made of each image. Each set has been identified by Roman numerals I to IV, and each book and photograph in the set has been numbered from 1 to 50. The four images selected for the deluxe edition are:

I CAPE COD 1972
II ELEANOR, CHICAGO 1949
III CAPE COD 1973
IV CAPE COD 1974

DATE DUE